THE *Black* MENORAH

The Black Menorah Is A Story-Poem And Masonry Mosaic
Artwork That Tells The Tale Of: Light Verses Darkness,
Good Verses Evil, And Right Verses Wrong.

BRIAN LEE ESTILL

To order additional copies of this book, contact:
Xlibris
1-888-795-4274
www.Xlibris.com
Orders@Xlibris.com

THE *Black* MENORAH

ACKNOWLEGDMENTS

Thank you YHWH for giving me the time and space to write and finish
this book and for giving me these people and business:

The love of my life:

My big brother Frank, and the rest of my brothers and sisters

My children and nephews

My Photographer and Graphic Designers

Curt May, Kyle Eberle, Patrick Johnston, Matt Mason

Business: Masonomics Inc., River City Development, Crown Trophy of Louisville.

Table of Contents

ho I am

Hi there friends,

My name is Brian Lee Estill and I am Kentucky's Greatest Folk-Masonry-Mosaic-Artist. In fact I am the world's first Folk-Masonry-Mosaic-Artisan. I know that is true because I made that title up myself, plus I googled it the other night. You see, if you're going to be great in this life, you need a great title and that one is mine.

I have been a brick and stone-mason in the Louisville area for most of my life (25 years). Louisville is my adopted home. I was born in Heidelberg, Germany. I'm an army brat. My mom and dad were born in Louisville, and most of my family is here. And plus I love this city and the Southern Indiana area.

I graduated from Detrick Vocational School and Atherton high. At Detrick I studied Masonry and worked in that trade for the last two years of high school. After High school I joined the Marine Corps. When that didn't work out I came back home and started working with my uncle in his body shop. When that didn't work out, I went back to the only other thing I know… which is Masonry.

I served a three year apprenticeship at the now defunct Construction Training Institute that was located on Poplar Level Road. I graduated in 2001 with a Certificate from the Kentucky Labor Department. I am very proud of that and the fact that I have had a hand in building schools, churches, hospitals and some of the nicest homes in Kentucky and southern Indiana.

These days, I have branched out on my own. My desire is to make a name for myself as Louisville's premier stone mason and to turn my craft into artworks like we all have seen on Facebook and Pinterest. You know what I'm talking about. I want to build beautiful stone fireplaces, boulder walls, and awesome looking pathways and much more like Lew French from Martha's Vineyard.

My other dream is to become famous for my art and poetry. My storied Masonry Mosaics. I plan on publishing some of them in their own books. I hope to sell them for as much as the market will bear. That's my goal anyway.

My company's name is: Estill Masonry Artworks. Please contact me if you are interested in hiring my company to build your home, business, church or whatever. And of course contact me if you would like to purchase the world's first storied-masonry-mosaic-artwork. Thank you for reading this.

brian.estill@gmail.com

\mathcal{W}hy This Book Was Wrote? My Vision Statement.

I am writing this book for many reasons. One is for my ego, (I have always wanted to be a published author), and the other is because I feel like I'm being egged on by the Holy Spirit. However, greatest reason being is that I have a vision of my artwork being auctioned off at Christy's Auction House or maybe Sotheby's? I can see that event happening as clear as day.

I am sitting in the audience of that auction house. It's being viewed from all over the world. This auction house is busy selling their items for over an hour now, I'm getting bored. Then they get to me. They hold up the Black Menorah, and I grin ear to ear.

Then they pause so I can read the story from a video I made. Cameras are also pointing at me sitting in the audience with my wife Tia. We are both supper excited and smiling. They know who I am and they have been anticipating this moment with me. Eager art collectors from all over the world are sitting up straight waiting to bid on my art.

I have created an artwork, published it in a book, it has its own Wikipedia page, and videos on you tube. It is placed firmly on the internet in many different websites. I made my artwork stand on its own two feet, now art collectors from all over the world getting ready to bid on it.

So it begins, the Americans Art Collectors drop out first, because they don't have the stomach to spend money on originals. They are so used to buying reproductions. Then the Russians drop out, after all they don't liked Jews anyway. China's not interested, they look like their sleeping.

Now there are two hungry art collectors left. One from Saudi Arabia who wants to buy with the intention of break it back into little pieces. The other guy is from Israel. The Israeli dude has the intention of buying it and giving it away to an Israeli museum. You see, he is at the end of his life. His family is taking care of

for many generations. He has enough possessions. All he wants to do is one-more-good thing. Just give it away, and bless a good family like mine with lots of resources to do well in his community.

So those two dudes duke it out for a while. And for a while it looked like the Saudi's were winning it. But right before the hammer falls. The Israeli guy came in at $58.5 Million. More than the previous Highest Earning Living Artist, Jeff Koons. Did you know that in 2013 Sotheby's sold his giant Orange Balloon Dog for $58.4 Million dollars? Making him the, "Highest Earning Living Artist in History?"

I see my face in this vision. I am in shock. My mouth is wide open. Tia is laughing and hugging me. She more excited than anybody else. Probably because she knows, I'm going to spoil her rotten. She knows she is just as much a millionaire now as I am.

However, she remembers all those times she told me, "What if it doesn't happen, what if it doesn't sell?" She feels silly now. I turn toward her and say, welcome to a whole new reality, baby you should have never doubted me.

Wow! I think to myself, I'm now a millionaire, I'm rich, debt free. What am I going to now? Travel the world? Buy expensive toys and houses? What will I do with my time? I'm rich! I don't have to sell anything else. I don't have to go or do anything at all I have financial freedom.

But that's not my dream. My dream is to use that money to patent my inventions and keep publishing books and open a rock shop in the Highlands of Louisville. Plus after 41 years I will finally buy (or build) my first house. In addition to that, I will buy the tools and materials that has held me back for so long. Now I will be able to pay the professionals. Make videos, whatever I can to promote my brand of Kentucky folk art. Now… there is nothing holding me back, accept me.

Nothing is going to stop me, even if I'm dead, I'm still going to be in that audience, watching my artwork being auctioned off to the highest bidder. And I see these artworks selling into the millions because of one reason. They all have a different story, something the Orange Balloon Dog, by Koons, doesn't have.

The next chapter tells you about my unusual experience that happen to me in 2009. This is how the Black Menorah came about. By slapping it and telling those stones to wake up.

The Back Story Of My Artwork

It was pitch black outside on a hot, muggy, June night. I was exhausted, suicidality depressed, and in my cousin's garage with the garage door opened. I was there because I was basically homeless. I had decided to break up with my ex-wife a few weeks before then. Our relationship, like many others, took a turn for the worse when I lost my job due to America's economic crisis going on in 2008-2009.

Besides she didn't understand who I was, what I was trying to do with my life. She didn't get me, so she could no longer have me. I told her I was done, then took my wedding ring off my finger and thumped it on the table like the old drinking game called quarters. Everything was quiet, it was a surreal moment. The ring flip end over end in slow motion.

I was angry over everything. Especially the fact that I didn't have my old job as a bricklayer because the economy was going through a depression. The housing crisis of 2008 finally came to Louisville with a louder bang and boom then any Thunder over Louisville celebration I have ever been too.

So I moved into my cousin's house and rented a small room from my cousin. We have always gotten along pretty good as kids. However, now that he had power over me, he was turning into a real ass whole.

We constantly were at odds with one another. It couldn't have been at a worse time. I was already depressed, suicidality depressed. I felt the way I did in the Marine Corps. All those years ago. So I checked myself into the VA's psychiatric ward.

I made my claim that I am still suffering the side effects of taking the anti-malaria drug called Melfloquine. And this drug has caused me permanent brain damage. Needless to say, they didn't believe me, so I had to get two relatives to write letters explaining how I have changed from when I went in from when I came out in 1997.

I also wrote the VA a personal letter asking them to consider as evidence the fact that one year prior to taking Melfloquine I was part of a team that won one of the hardest and most grueling contest in the military, just short of Seal or Ranger training : The Marine Corps Super Squad.

"Just look at my record" I pleaded to my VA examiners. "Look here", I went from a proud Marine who was a winner of something great; to a miserable wreck of a man who turned a gun to his head and pulled the trigger twice. How does that happen?

I was well adjusted in military life prior to this moment in time. I was setting goals and achieving them. In fact, I was happy with my life up until that first white pill called: Melfloquine. A friend of mine named Daniel Costa Roberts wrote an article about this drug. While he never published it with his people the article looks at the history and mystery surrounding this drug.

What happened to me? I can't explain it any other way. I had been carrying around the guilt of giving up my three year Marine Corps career for over twelve years. Not to mentioned, letting my family down. Especially my Marine Corps, Korea War Veteran, grandfather. I hated that the most. We weren't close anymore, he barely could look at me. I failed myself, I failed my family, and I was a disgrace.

So with all that junk in my head, I went back to work in my cousins garage. It was late at night. I was exhausted mentally, physically and spiritually exhausted. It was around three in the morning and I was ready to call it a day.

That's when I heard an invisible voice tell me to "Slap those stones and tell them to wake up." That's all it said; but it kept repeating itself until I did what I was told. So I slapped my mosaic called Man in the Mirror, I seen letters turn into words. Words that made a paragraph, it had a plot with characters and rhythmed!

And from that voice a new legend was born. A legend that me and twelve other people have believed in enough to kiss this mosaic artwork of mine. What was weird to me was I had a flash back. I remembered being in Jefferson Community College downtown Louisville campus in 2004. I was in my first semester of college again. I was researching a paper for an art history class I was taking.

I was flipping through books when I came across a cool image of a marble statue of a Knight from Ravenna, Italy named: Guidarello Guidarelli. For about five minutes I stopped long enough to read about this guy. Then I moved on, read other books and things and forgot all about it till that moment.

I remembered his legend and remembered that he cannot be kissed anymore. It seemed there needed to be something else in the world for people to believe in. And so that's when the poem and the idea of the legend came to me, in that moment. I didn't have to think about it at all. It just happened like the rest of my artwork and story-poems.

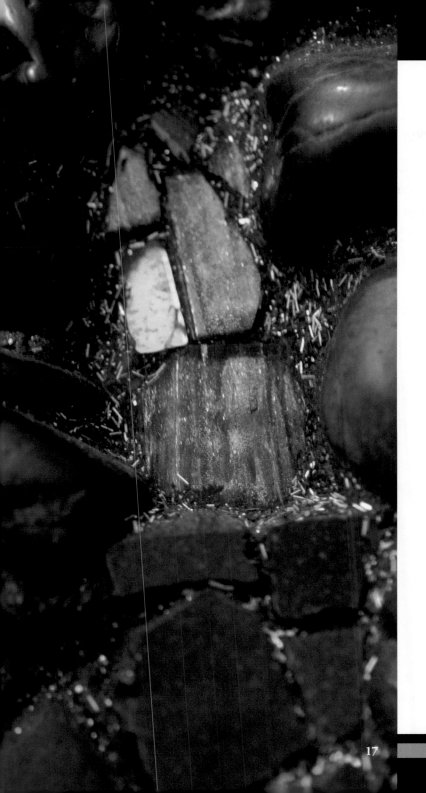

The Black Menorah
Story-Poem

*1. And the seven shinning ones say…

*2. "Here lies a lantern
All cloaked in black
It chases away the darkness
But still… the darkness keeps coming back

*3. The light of its copper rays, reveals our ways
Leaving nothing but memories as our shadows fade…

The cold darkness says…

*4. "Children of the light thinks they will live forever
But I the darkness am too clever
"Never say never… child,
Where can you run?
When down goes the setting of your one and only sun…
When sleep and darkness… become… one.
*5. "I was the light bringer; then he shakes his finger
And says, "Just you come, oh just you come
Come on over to my side
Where there are millions of places, for your light… to hide"

The seven shinning ones replied…

"You're all dark and bleak, you're evil is weak.
You live in darkness and that's evil you speak
We will outshine, make you go blind, and do it every time…
Be all shinning when are we whooping your behind

*6. There was red lights, and purples, and sparks of green
They spoke into the darkness,
Speaking of the white fire they had once seen
They warned the darkness, "You need to leave and you need to go!"

*7. Then all a sudden there was an exploding copper glow!
A voice spoke and said,
*8. "Let's rid ourselves of all this fauna and flora,
The lamp may be black
But it's still our menorah!"

It will still light us away, get us away,
Find us away, far away from you…
Our light will shine forever,
We'll be fine, our time is not yet due…"

Darkness responded…

With a deep growly voice,
Deep and slow…he whispered "Dear child of light
Run in fun, run in delight, run until you're out of my sight
But don't be so fool-hardy to get into this fight
Your timing is just not right, then he shook his finger

*9. I was the morning star! I was the light bringer!

The mightiest of all the angels, and heavens' greatest singer!

I am slow, organized and neat
I can't be beat,
You will burnout one day
And I will never feel your heat
So if you ask me, (with a grin)
You're the one, who is weak…"
Then the seven shinning ones spoke

"Draw near to our heat, the copper glow
"You can feel right here, (pounds their chest)
You can feel our, fiery soul
Now you just say when,
Cause were ready to go
Were fired up now and were starting to grow…

Mr. Morning star,
You're nothing less than a wretched mess
Just murky, dark and bleak
Pitch black tar, coal and soot
On your neck… is our foot!
And yes you are!
You are weak!"

*10. The darkness creeped slowly and closely
Wanted to see how friendly he could be, mostly…
Engulfing the lantern in heavy black stones
Nearly choking out its copper flame
A little flicker is all that remained

With faith, they believed without a doubt
*11. They knew the mighty one would resurrect them
And they would stand again, be left standing
Strong and stout
The cold inky darkness…

Tried to kiss the flame, to make the lights go out
He can only win, when our lights go out
His kiss of life is the kiss of death
And that's what the light bringer is all about

*12. Then the copper glow shouted…

Wake up my lights, lights of every color
*13. Come together in the land of our mothers
Come together in Israel's name
So that the light bringer can burn in, our…flame
*14. Let's turn our back on the land of Sodom and Gomorrah
Let's go to the land of Jerusalem,

And let's go forward with our,
Black Menorah

Then the cold blackness…

Rolled in like a smoky fog
Like a inky black liquid, like an oily black blob
*15. It was thick with black granite, thick black shale
Thick with black river stones
Freezing to the touch and colder than hell

*16. The Menorah was being choked by the darkness,
It's last copper glow it almost gave
*17. When all of a sudden, some more light cut in,
The darkness started to quickly fade…
It started sprinting trying to find shade
With a booming voice closing in fast, saying…
"Get away! Get Away! That's my children, the one's I made"

*18. Bursting forth a white light

Ten thousand times greater than our sun
It poured onto everything
It couldn't be turned down… nor undone

All the darkness could do is… run, run, run

Poor darkness was nearly destroyed…
The cold blackness, that empty void
Hide where it could, but it was no good,
Tried real hard as anybody would

There was nowhere to hide, he was stomped in his side
There was no where he could have hid
When the white light broke all his ribs
Messing with the white light
Is something he should have never have did…
Crawling away in black coldness
Because that's all the life he had, and could give…
When the cold emptiness' tried to quicken his pace
He got kicked in the face

The voice from the copper glow spoke and said,
You're a wretched mess, I must confess
Just murky dark and bleak
Ol' Morning star, ol' coal and soot
On your neck… is my foot!
And yes you are! You are weak

The Seven Shinning Ones Say,

We all make our mistakes and that… we all know
So don't you ever again mess with the copper glow!
Land of milk and honey, children of Torah
Keep this Lantern, this Black Menorah
An always embrace the light and warmth of our Torah
Watch the cold darkness, just fade away,
Never to come back, just fade away

Here lies our menorah, all cloaked in black,
You might feel lost so see yourself back,
Back on the right track, come back home
You want to feel the Temple? The land of Israel?
*19. Then come feel the Black Menorahs, Dead Sea Cornerstone
With millions of lights singing all in tune
The darkness still promised to be back very soon
With suffocating heat against the dark cold
We don't know how the Darkness spoke so bold

*20. And all over the skies, were many auroras
Shinning their light on: The Black Menorah
And that is how the story ends, and that's how it is told
The once Black Menorah, rising to heaven
Turning in to gold! Amen.

Explanation Of The Asterisks In The Black Menorah Story-Poem

1. *"And the seven shining ones say..."*

When I wrote the story I was thinking of the individual copper flames in my menorah. However, I recently discovered a verse from Revelations 4:5 where the "Seven Shining Ones" refers to angels around YHWH throne were compared to seven lamps. I think that is interesting.

Revelations 4:5 *And out of the throne proceeded lightning and thundering and voices: and there were seven lamps of fire burning before the throne, which are the seven Spirits of God.*

2. *"Here lies a lantern, all cloaked in black"*

The Menorah is above all a lantern. And unlike other poems of mine, where I started in the middle and fought my way out. This poem began has it is and finished itself with little editing on my part. Furthermore, the menorah is the oldest representation of the Jewish people way older then the Star of David.

3. *"The light of its copper rays, reveals our ways*
 Leaving nothing but memories as our shadows fade…"

I am making a reference to the copper tiles I laid in this mosaic artwork. Also this verse, I believe is a reference to our mortality.

4. *"Children of the light thinks they will live forever*
 But I the darkness am too clever
 "Never say never... child,
 Where can you run?
 When down goes the setting of your one and only sun...
 When sleep and darkness... become... one.

Children of the light is another term of the children of Israel, both Christian and Jew. In the New Testament the Children of the light phrase is used four times.

Luke 16:8
John 12:36
Ephesians 5:8
1st Thessalonians 5:5

In the last part of this stanza, butt face is threating us. Rubbing it in our nose that there is no escaping him in this life and world. Where can we run? When down goes the setting of your sun (son)? I have an image of Christ dying on the cross, of death which could be compared to sleep until we are awakened in the afterlife.

5. *"I was the light bringer"*

Light bringer is Latin for Lucifer, and refers to his role in angelic hierarchy before his fall from grace.

6. *There was red lights, and purples, and sparks of green*
 They spoke into the darkness,
 Speaking of the white fire they had once seen
 They warned the darkness, "You need to leave and you need to go!"

The red lights, purples and sparks of green is in reference to the glitter grout used in the construction of the mosaic artwork. The copper flames are talking about the white blinding light of YHWH

7. *Then all a sudden there was an exploding copper glow!*

The exploding copper glow is the individual copper flames harmonizing and therefore combining their energy to defend themselves from satan.

8. *"Let's rid ourselves of all this fauna and flora."*

This could be a reference of going back to a time before creation of the world. Fauna is animal life, flora means plant life. I didn't know that prior to writing this. I have never used that terminology before in a conversation. I wrote that because that's what I heard in my head. Further proof that this poem did not come from me.

9. *I was the morning star! I was the light bringer!*
 The mightiest of all the angels, and heavens' greatest singer!

Morning star is also another name for satan and the planet Venus. It is mentioned in the bible several times. It also is a title given to satan before its fall from grace. Somewhere I must have read that satan was a singer in a heavenly choir? However, folks this is automatic writing. I didn't try real hard to make these words come out as they did. It's very difficult to explain some of this and where it came from.

10. *"The darkness creeped slowly and closely*
 Wanted to see how friendly he could be, mostly…"

The greatest lie satan ever told was he doesn't exist. Often times he is in stealth mode you never know just how close he is to you, until it's too late. When you meet him he seems friendly enough, like a buddy. But watch out! It's a trap.

11. *"They knew the mighty one would resurrect them*
 And they would stand again, be left standing
 Strong and stout"

The might one is another name of YHWH, it means ELOHIM in Hebrew. I believe this is a reference to several biblical verses about "standing firm."

12. *"Then the copper glow shouted…'Wake up my lights, lights of every color'"*

This verse is in reference to the harmony of the copper flames in the form of a copper glow. Could these seven shining ones be the same as those mentioned in revelation 14? Also I believe it is talking about the glitter grout or electricity in my Black Menorah.

13. *Come together in the land of our mothers, Come together in Israel's name*

According to Jewish law. A person is considered being Jewish if there mother was Jewish.

14. *"Let's turn our back on the land of Sodom and Gomorrah, Let's go to the land of Jerusalem"*

Sodom and Gomorrah were two cities destroyed by YHWH in Genesis 18-19. They also represent America or maybe the world we live in today. I think it also gives us believer's encouragement to bring about prophecy by moving to Israel.

15. *"It was thick with black granite, thick black shale, thick with black river stones"*

This verse speaks about the physical artwork. It is talking about the building materials I used to construct the black menorah. By now, there shouldn't be any doubt in anyone's mind about whether or not this poem belongs to this artwork.

16. *"The Menorah was being choked by the darkness. Its last copper glow it almost gave."*

This verse could probably be why it's called the Black Menorah and why the only bright color in it, is the copper flames.

17. *"When all of a sudden, some more light cut in. The darkness started to quickly fade..."*

This is the climax of the story. This is the tuning point that you and I have been waiting for.

18. *"Bursting forth a white light. Ten thousand times greater than our sun."*

Has it says in scripture YHWH is light. A blinding light that if you look at the face of YHWH you will surly perish. Exodus 33:20 "No man shall see my face and live" This verse reminds me of when Moses came down from the mountain and had to wear a veil because his face shone like the sun.

19. *"Then feel the Black Menorahs, Dead Sea Cornerstone. With millions of lights singing all in tune."*

Absolutely there should be no doubt about this poem's connection to the artwork. My corner stone came from the Dead Sea in Israel, it was given to me by a dear and trusted friend who collected it when she and her family were there. The millions of lights singing all in tune is a reference to the glitter grout I used, but could also mean all light captured in a prism.

20. *"And all over the skies, were many auroras"*

The artwork that you see in this book was done by my daughter Sarah. She is 16 years old. I bought this artwork so that she could be inspired to keep creating. I didn't know that she was drawing the Aurora Borealis in school. She didn't know I wrote about it in this poem. Weird huh?

The Other-Half Of The Black Menorah Story-Poem

I am the Black Menorah
A shadow of what's to come
A once cast spell, is now left undone
I am the Black Menorah
A shadow of what's to come
All our sins added together has matched their sum
I am the Black Menorah
And I stand real strong
And if you do too then you come along
Someone else will have to carry this lantern when I'm gone

Other Fine Folk-Artwork
By Brian Lee Estill

1
Rocks of Fort Knox (R.O.F.K.)

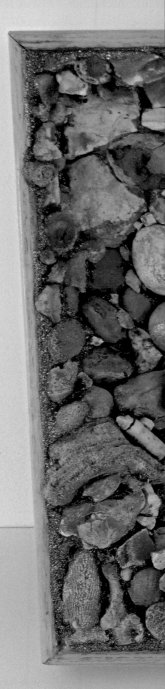

Rocks of Fort Knox is a story poem about an Army family who loses their solider in Iraq. I insert myself into the story as the main character Tommy Fox best friend. We take long walks and collect biscuit and muffin shaped rocks. Tommy loses the match box toy car in the middle of the mosaic at the same time there is an ominous knock at the front door.

He and his mom learn that dad was killed in action. At the funeral, Tommy admonishes us to not take our freedoms for granted. This is the greatest Veterans Day poem ever told. This will be the second book I will publish. It will feature color photographs of the neighborhood and playground in Fort Knox.

Little Tommy was always brag'n that his Daddy was in the "au-me"
Couldn't understand why Mommy was in such a fit of tears
Is something wrong with Dad he wondered?
And then she sat him down,
And told him,
Confirming his worst fears…

Tommy was angry, he was bitter, and he felt slanted
He said he "**Hated all his fellow Americans who are taking their freedoms for granted**"

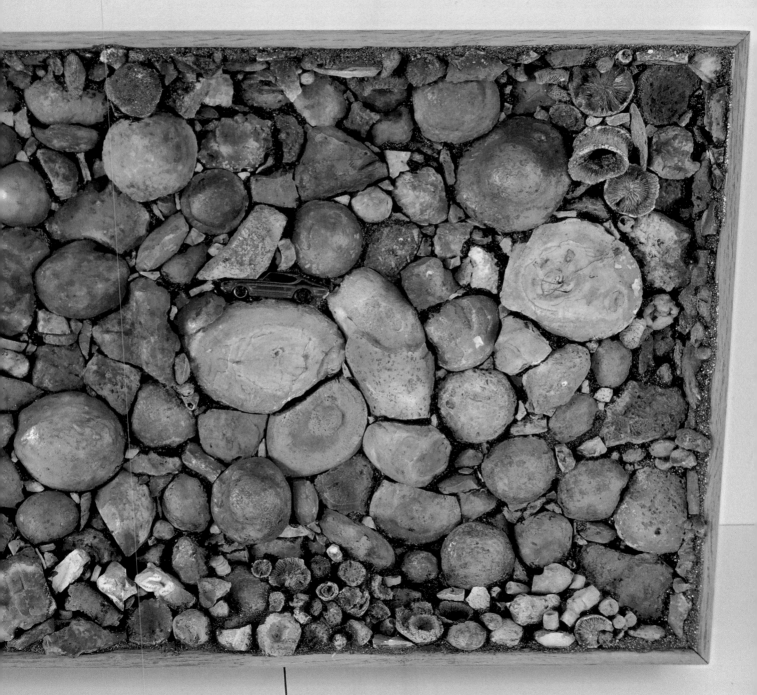

2
Johnathan Greystone

Johnathan Greystone is a story poem about a boy who was born with wild green hair. He attend three of Louisville's south end schools. He was born with cancer, and is almost always depressed. He gets bullied but eventually overcomes there relentless insults, with bravado.

(Sally; one of the girls that insulted him) becomes his prom date. Sadly though, after prom night he succumbs to his cancer at Kosairs children's hospital. This book will have illustrations and color photographs of these schools, hospital, and be in memorandum to the children like Johnathan who died of cancer with still in high school in the Louisville school system.

Wasn't long after that night, he lost his fight, he succumbed to his cancer. But no one will ever forget that green haired boy was a fantastic dancer. A robust romancer, ol' mustang Sally says there was no one fancier, so he cannot be ignored. And that's how he will be remembered, forevermore. His dying last breathe, he said, with tight, tight, lips, hands close to his hips, "You won't forget me anytime soon, he said with a quick little quip! "I am Johnathan Greystone and I never quit." There was a birthday, then a death day, in-between those…was a dash. Johnathan's life went by way too fast. One day they will find a cure for cancer, but no one will ever forget that green haired boy was a robust romancer, a fantastic dancer, there is no-one fancier, and he didn't die alone. We were all there, at Kosairs Children's Hospital in Louisville, Kentucky holding the hand of Johnathan Greystone.

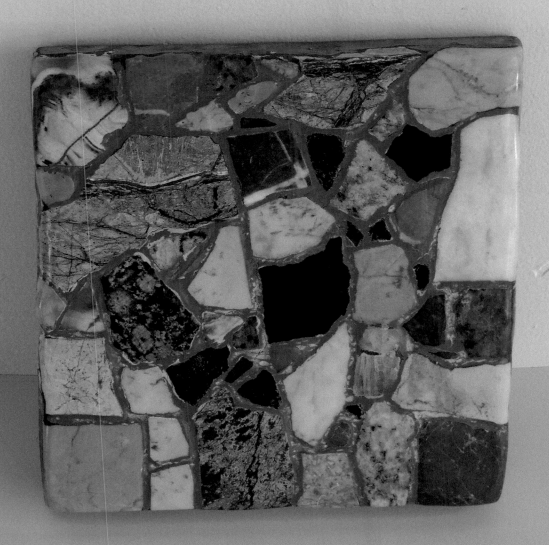

3
Phrankie the Phoenix

Phrankie the Phoenix is a story poem about the old Phoenix Hill Tavern located in the Highlands of Louisville, Kentucky. At the time of writing this poem I was working there as a bouncer in 2010. In this story, Phrankie is the matron of this tavern and she is one bad ass lady. The name came from the real matron of Phoenix Hill Frankie Rogers. The Rogers family started, owned and operated this night club for over 40 years. They turned into a Louisville destination, then closed it abruptly in 2014.

In the story-poem, nobody dares to mess with Phrankie the Phoenix for fear they will get burned. In the last verse in the poem, I anchor this now defunct favorite tavern of mine to the location by referencing Cave Hill Cemetery. A must see for any visitors to Louisville. I imagine the book to have illustrations of the poem and color photos of the Phoenix Hill Neighborhood and of course Cave Hill Cemetery.

From the fire that licks at the flame
Don't try and hold her! NO she won't be tamed
If you ever get in her way; you'll not soon, forget her name
Because she's no pet, NO friendly bird of prey…
And you soon regret; that you ever got in her way

In Louisville, Kentucky,
Where Cave Hill Cemetery, runs deep with its cavern
Lies across the street to Phrankie the Phoenix of
Old Phoenix Hill Tavern

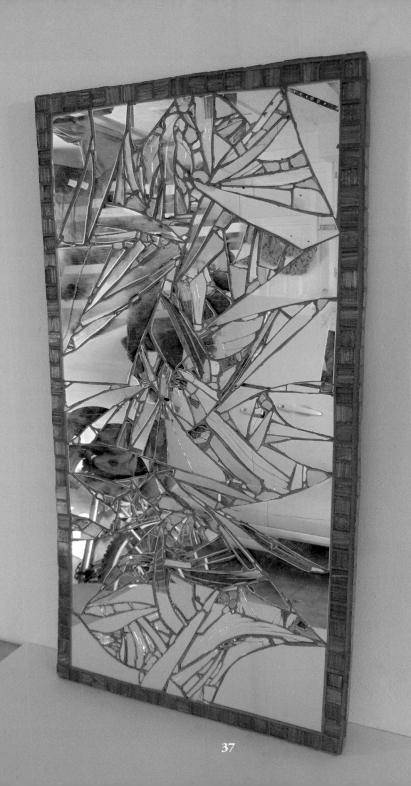

4

The DAVille Monsta

This story poem is about a blue bellied, bastard faced, wild cat lady named: DaVille Monsta. DaVille Monsta is the ghetto way of saying Louisville Monster. What's so funny to me is I have to write that for some of you to understand and I know some of you won't get it.

It's a story about basketball. A little cardinal bird named Buster, and wildcat fans that live in five neighborhoods in Louisville, Kentucky. Including a humiliating little song for University of Louisville basketball team. This story was written about the 2013-2014 season. At that time, I was following the University of Louisville and University of Kentucky playoff games.

I was hopeful that U of L would win. I am a cardinal fan, however, I also jump of U of K's bandwagon when they take it all the way like they have before. I envision being out at another U of L and U of K game and U of K's fans teasing the U of L fans by singing the DaVille Monsta song. "Much, Crunch, Ol' bridle redbird bones for lunch." How funny that would be.

The Deville Monster was a nasty, rancid, smelly, sinner. A blue bellied wildcat who ate redbirds for breakfast, lunch and dinner. And if you asked her for the truth, she would say, she never felt better, nor looked thinner. Then she tilted her head, just a little, smiled and said, "When those redbirds are going down my hatch, they all taste like winners!

And with a wicket little laugh, she blew me a kiss, burped, then up came a red feather. The Louisville Cardinals had enough and flocked together. Posted up near her home, on power lines and trees. There were thousands of them, including me. We had her surrounded, impounded, but still, I know she would still get free. Then for a moment, there was silence… Munch, crunch, ol bridle red bird bones for lunch. Then she burped and up came a red feather…

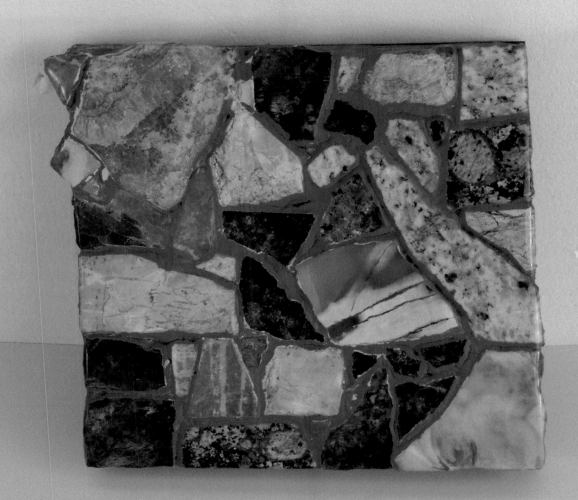

5
The HEMet of His Salvation

This is the most dangerous hat in the world. Seriously, it could be used as a weapon! Made from mirrors and metal trinkets that I bought from a hobby store. The three wings on each side of the "Helmet", represent the Seraphim Angels. The seven jewels that embellish the crown represent the seven spirits of God. The crown is to remind the viewer that yes there is a king over all the chaos of this universe.

The Helmet of His salvation is my latest creation. I made it in January 2017 and am still experimenting, so not done yet. This unique hat weighs less than a pound. I matched this artwork with a story poem with the same name that I wrote in 2007.

This is the third hat I have ever mosaicked. The first was a cowboy hat where I mosaicked the front of it with a few tumbled stones and fossils. I sold it not long after making it. The second was a fedora hat that has been destroyed by me because I was trying to make alterations to it but messed it up.

The Helmet of His Salvation was a fun project. I would love to do more than three. I would love to do one you. I would love to branch out from doing brick and stone work to mosaicking hats. I even thought of a name for this business. Derby Hat'z for dudes. In case you're not familiar with the Kentucky Derby, women normally wear the over-the-top hats.

Throughout heaven there was a great elation
For Yeshua was putting on the Helmet of His Salvation
It was the last piece of armor left for him to bear
An when He put it on, a great applause was heard everywhere
And then heaven witness him mounting a great and powerful white stead
Wearing the full armor of YHWH with no other need
He goes forth to wage war on the nations
For it was witnessed by all of heaven
Yeshua dawning on
The Helmet of His Salvation

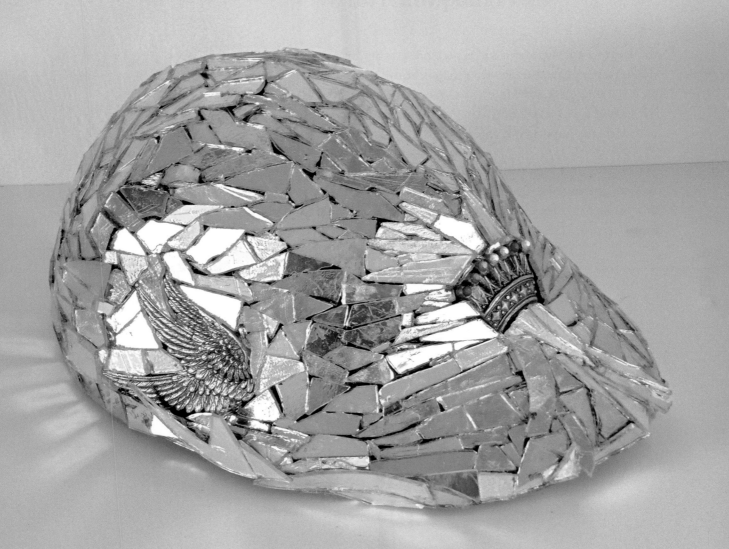

41

6
Melfloquine Mars

Melfloquine Mars is about my experience taking the anti-Malaria drug Melfloquine. There are two ways to look at this artwork. One is straight on, it is a snap shot of what my brain looked like after taking this drug. The second way to look at it. The Mars view, can be viewed as if you're in an airplane looking out the window.

The browns and tans could represent the deserts, the green could be trees, and at any rate, the landscape looks mosaicked. The mortar that's built up on the sides could be mountains? I don't know, this mosaic was done free style. I didn't plan any of it.

On board the USS Guam
While serving in the Marines
I was ordered to take a little white pill
That gave me strange dreams
I felt dizzy in the beginning

Then angry and confused
Somewhere in the Atlantic
My mind I would loose

The SEA Lilies of South Louisville

The Sea Lilies of South Louisville is a short story poem and artwork I created in 2010. The artwork is made out of 350 million year old crinoid fossils. I collected these fossils from the park in 2003. I didn't know it was illegal then, in fact there's not a sign saying you can't do it, so maybe it's not. I carried them with me to every house and apartment I have lived in, until 2010 when I create this mosaic. Personally, I think by carrying these heavy, clunky stones for all those years is punishment enough.

This is the heaviest mosaic I have made. It weighs in at almost 50 pounds. When I was building it I kept thinking about how awesome it would be to build a fireplace of water fountain out of these stones. At any rate, it could be used to teach children about earth sciences like: Geology, Paleontology, and Mineralogy. Which is something I wish someone would have told me about when I was in elementary school.

The story-poem speaks about Church Hill Downs and Iroquois Park because both are located on opposite ends of Taylor Blvd. At the time of writing this poem I was living on Taylor and Camden Ave. These fossils are some of Louisville's oldest history.

In the poem, I introduce myself as the main character. I tell the reader that I'm a stone mason/rock hound and when I found them I thought I struck gold because I thought they were worth money. Anyway, it is a silly poem but it's what came out of my soul at that time. It probably won't make much sense to you. But at least it's something right?

The Old Sea Lilies of South Louisville
Are found very close to the Park of Iroquois Hill
Down the street from my Old Church Hill
And if they were in that park
Then I certainly didn't mean to steal
These our Louisville's lovely lilies made for my fillies
That runs at my Old Church Hill

350 million years old, if I may be so bold,
When I found them I thought I struck gold

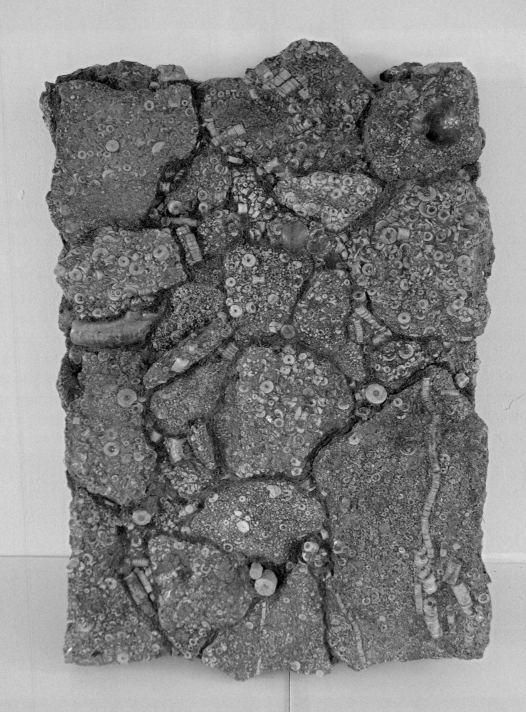

7
Man in thE MIRRor

I previously mentioned Man in the Mirror in the beginning of this book. This is the first mosaic to "speak to me". These are the stones that I first woke up. And this my friends, is the gayest artwork in the world. Think about it. In order for this legend to work for you, in your life, you have to kiss this abstract man's penis.

I didn't think about it when I created this mosaic. I originally set out to re-create (in the miniature) that huge patio on Maryland Ave near Cherokee Park that was made out of the remnants of granite and marble counter tops that I helped to repair.

The image of the abstract man came to me the instant I slap this mosaic. And that's the same way all of this has come to me. So far eleven people including myself have kissed this mosaic. We have signed our names in a book. Not everyone found there true love, but I did. Tia and me have been together since 2010 and plan on getting married very soon.

Furthermore, I feel kinda guilty for having this mosaic hanging on my wall next to the Black Menorah. Because of the legend associated with this mosaic, I feel like it has become some kind of false idol of worship. Man in the Mirror wants to outshine all my artwork and become the golden calf. I'm not going to let that happen. I will destroy it if nobody buys it. You should buy it before that happens, because kissing stones is cool. Ever heard of the blarney stone?

They the people, the lonely hearts, lonesome and broken
Here I left for you… an ageless token…
Within a month…if it be both your desire
Shall you find your true love, who rekindles in you, youthful fire…
Your true love, the one from heavens above
They shall no longer tarry…
For within a month, you shall meet your lover
And you just might be getting married…

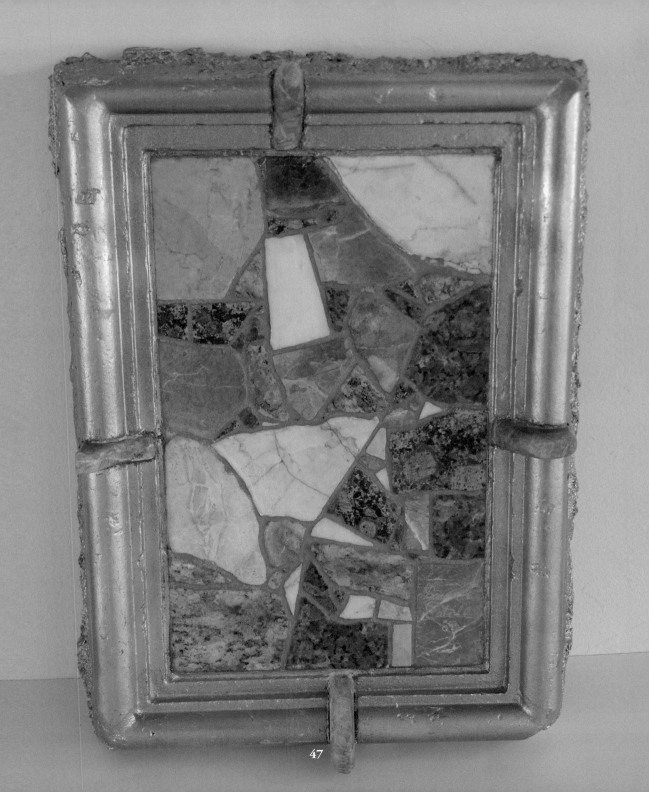

8
Wolf TICKets

Wolf Tickets is slang for lying. It was thought to have started in the 60's by black folks. Don't sell me wolf tickets is the same as saying don't lie to me. I heard it from a black labor I was working with. He was older than me and I really liked that guy for his honesty. He had a great work ethic too and made us all laugh all the time. These are important qualities to have when you work as hard as laborers for bricklayers do.

Built into this mosaic there is a coffee cup from the Great Wolf Lodge in Kings Island, Ohio. The coffee cup has the name Mary on it. The name has been broke in to two pieces. Can you find them? I mention the name of the gate keeper in the story poem as being Mary. The poem tells the ageless tale of crying wolf but my story doesn't it in a really cool rhyming style.

The boy said, "I wish I could fix it, but I can't. It's what I do".
Then that nasty boy laughed and said, "I sell whoooof tickets"
Then he yelled, **"They're here! They're here! The wolves are here!"**
As the good town people ran down that same ol path.
They seen that they were lied to again and were full of wrath

Mary the gate keeper said angrily, "One day it's gonna happen to you!
You better watch what you say and watch what you do.
Because that's the truth, and you can't trick it!
Stop Boy! Stop selling your, "Wolf Tickets!"

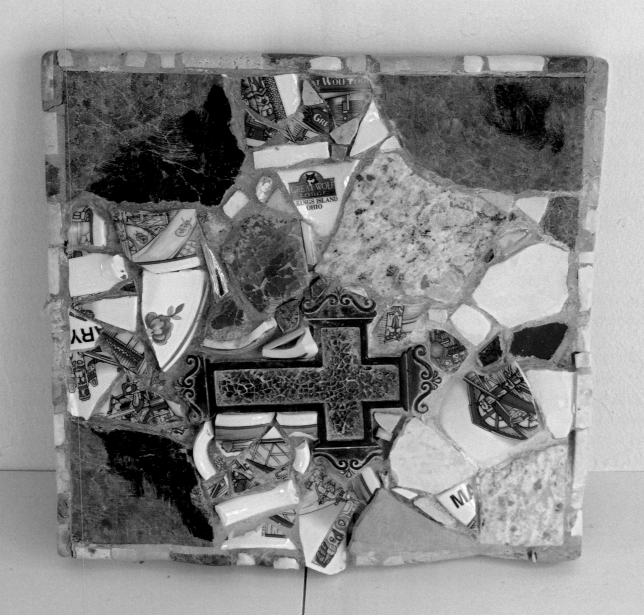

10
*O*l' SandY HOOk

Ol' Sandy Hook is a story poem I wrote in 2012 about the Newtown, Connecticut school shooting. In the poem the angel of death comes to take the soul of a mother. But god tells him to stick around for a while. So the angel starts walking toward the elementary school. He sees the shooter get out of his car and he knows exactly what's going to happen next.

He looks up to God at the same moment he hears BANG, BANG, BANG which is the poems climax. I never mention the shooters name because I do not believe in giving monsters like that any credit.

However I do mention the names of the principle of Sandy Hook: Dawn Hocksprung and one of the students Emily Parker. I was inspired to write their names because of the interviews I watch on T.V. with their relatives. This is the most powerful poem that I have ever wrote. I tear up every time I read it. I keep thinking that could have been one of my children.

This poem is a two part poem. The last part the angel of death delivers 26 souls to the pearly gates but one would not be let in and it was no mistake. Then the angel turns into the reaper and scolds that pathetic little monster while holding the Lambs Book of Life. As you might have expected, the last line of the poem, the little monster is sent to straight to hell.

About the pink marble-masonry-mosaic-artwork. In 2011, I bought a box of pink marble tile. The goal was to create miniature patterns of stone work. I created maybe ten or more 8"x8" mosaics out of that box. But one stood out among all those. It had a little violent pink vein shaped like a Y with a hook. Something told me to pick that one.

And the Angel of Death stood there weeping
Early in the morning of December 14th,
When the little village of Newtown was sleeping
He thought his trip would be for one, and not any others
He was sent, because a disturbed son
Had murdered his own mother

Walking around on grass and clover
He heard the One on High say, "You're job is not over"
He had arrived there early; the morning was crisp and cool
He started to head toward, the elementary school
Anxiously waiting, nervously pacing
He didn't want to be there, his thoughts were racing
**"Why oh Lord have u sent thee,
This is a school and no place for me!"**

11
The CHRIStina Marie

This story-poem deals with the mental illness of bi-polar. Apparently this mental illness is passed on from one generation to the next. Christina Marie was wrote for my sister but it could be also wrote for me. After all Brian Lee rhymes just as well as Christina Marie. However, I believe that my bi-polar illness was cause or made worse by taking Melfloquin while serving in the Marines in the 90's. Below is an excerpt from the beginning of my poem.

There are two sides of her, that everyone knows
One soars with the Eagles on high
The other sinks to new lows
It's here we begin, and we will take it slow
Because that's how all good stories, should go

Having lost her faith and dropped her shield
She doesn't care anymore
And tears down what she builds
Like an echo,
She'll bounce back, you watch and see
She's not called for nothing
The Christina Marie…

What I love about this poem is the way it flows up and down. Like the disease, there are hi's and lows all the way through to the end, where it ends with her coming back up.

The artwork is two parts. It is made from found ceramic pieces of plates and marble. There is an abstract face of a woman, and silhouette of a woman dancing. The other masonry mosaic compliments the first mosaic by having the same pieces of plates. These mosaics represent the two side of her or anybody who suffers from this chronic condition.

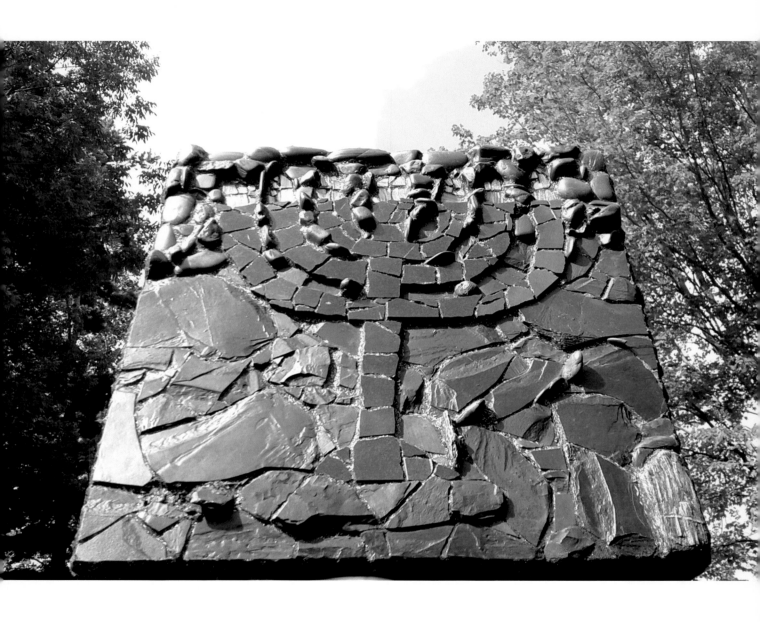

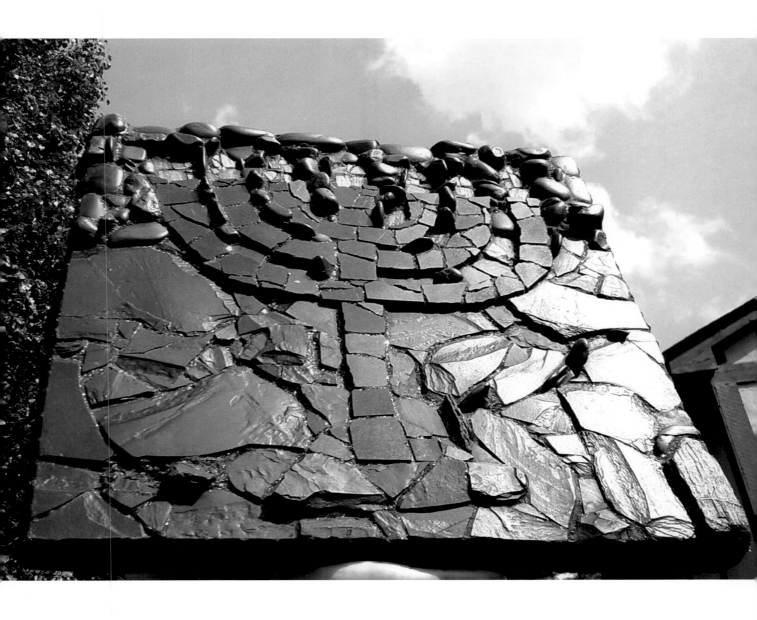

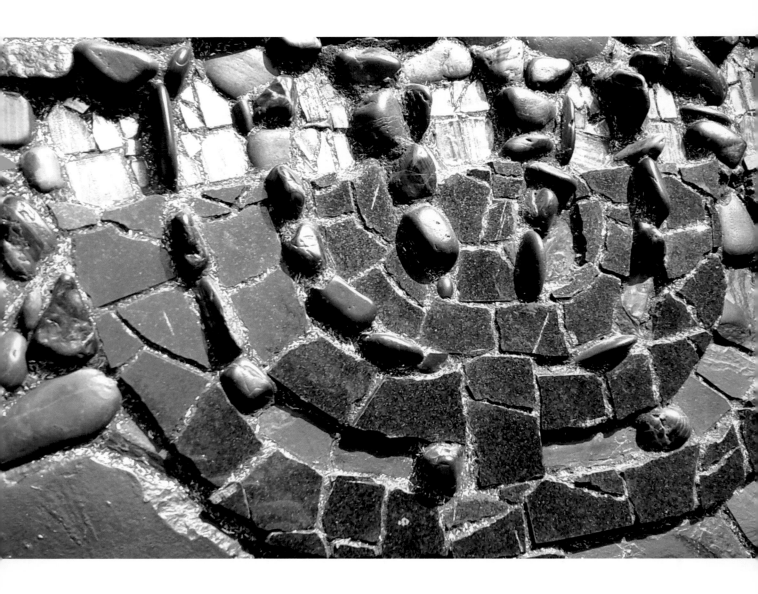

TITLE: THE BLACK MENORAH

ARTIST: BRIAN LEE ESTILL
MADE: LOUISVILLE, KENTUCKY
SIZE: 16.5 X 17 X 1.5
WEIGHT: 13.6
DATE: NOVEMBER 2010, STORY-POEM ADDED SUMMER OF 2014

MEDIA: BLACK RIVER STONES, BLACK SLATE, BLACK GRANITE, GREEN SANDSTONE, BLOOD, SWEAT, SPIT, AND TEARS.

OTHER INFO: I HAD NIGHTMARES FOR THREE NIGHTS IN A ROW WHILE WRITING THIS STORY-POEM. THE CORNER STONE IS FROM THE DEAD SEA, ISRAEL. THIS POEM WAS INSPIRED BY SLAPPING THIS MOSAIC AND TELLING THEM TO "WAKE UP." THE GLITTER GROUT REPRESENTS THE STRENTH OF YHWH.

One LASt thing

This may not be the best book you ever read, but at least it's an honest one. I have tried my very best to entertain you with my words and dazzle you with photos. I feel like I have given my best to you and I am hoping somebody out there sees the value of what I have done and contacts my business to buy my artwork for a substantial price or hire my business to brick and stone their home or business.

One day I hope to sit down with an illustrator and illustrate these as children's book's This is another reason I have decide to publish this book and try and sell my art to the highest bidder at a famous auction house like Sotheby's or EBay. I am calling you CEO's out. Please somebody tell them about me. I can't afford any more debt.

I have done this because I want a chance to be great. A great artist and story teller. Because my business needs funding. I have too much stupid debt and I need employees, a studio and materials. I need to pay the professionals. If you own a business than you know what I mean. Anymore loans are out of the question.

Art collectors of the world? Come and get it. You won't find nothing else like this work anywhere on earth. I'm one of a kind, original and Louisville, Kentucky's Greatest Folk Masonry Artist. I am the Grand Poohbah of Storied-Masonry-Mosaics, and I hope you have enjoyed my small book. Thanks for reading.

To Contact me:

brian.estill@gmail.com

Description Of Artwork

TITLE. THE BLACK MENORAH

ARTIST. BRIAN LEE ESTILL

MADE. LOUISVILLE, KENTUCKY

SIZE. 16.5 X 17 X 1.5

WEIGHT. 13.6

DATE. NOVEMBER 2010, STORY-POEM ADDED SUMMER OF 2014

MEDIA. BLACK RIVER STONES, BLACK SLATE, BLACK GRANITE, GREEN SANDSTONE, BLOOD, SWEAT, SPIT, AND TEARS.

OTHER INFO. I HAD NIGHTMARES FOR THREE NIGHTS IN A ROW WHILE WRITING THIS

STORY-POEM. THE CORNER STONE IS FROM THE DEAD SEA, ISRAEL. THIS POEM WAS INSPIRED BY SLAPING THIS MOSAIC AND TELLING IT TOO "WAKE UP." THE GLITTER GROUT REPRESENTS THE STRENTH AND ELECTRICITY OF YHWH.

Printed in the United States
By Bookmasters